WINSOR & NEWTON

The World's Finest Artists' Materials

colour mixing guides

water colour

a visual reference to mixing water colours

JOHN BARBER

First published in Great Britain in 2006 by
Search Press Limited
Wellwood, North Farm Road
Tunbridge Wells
Kent TN2 3DR

Copyright © 2006 Axis Publishing Ltd

Created and conceived by
Axis Publishing Ltd
8c Accommodation Road
London NW11 8ED
www.axispublishing.co.uk

Creative Director: Siân Keogh
Editorial Director: Anne Yelland
Production: Jo Ryan, Cécile Lerbière

ISBN 1-84448-176-X

The Publishers and author can accept no responsibility for any consequences arising from
the information, advice or instructions given in this publication.

Printed in China

Winsor & Newton, Sceptre Gold, Galeria, Winsor and the Griffin device are
trademarks of Colart Fine Art & Graphics Limited

Details of your local Winsor & Newton stockist can be found on the
Winsor & Newton web site (www.winsornewton.com)

contents

introduction **4**

how to use this book **8**

papers and brushes **10**

the colour mixes **12**

yellows **14**

reds **24**

purples **34**

blues **40**

greens **50**

neutrals **56**

index **64**

introduction

In the West, water colour as a medium developed from topographical drawings worked in monochrome grey or brown ink. Although several artists emerged to produce works in the medium during the 18th century, it was J.M.W. Turner (1775–1851) who developed water colour into a serious competitor to oil painting through his choice and use of colour. Today water colour is the medium of choice for thousands of painters working in a variety of styles and a broad range of subjects.

ABOUT THIS BOOK

This book on colour mixing using water colours is intended for both amateur and professional artists, and should prove invaluable both in the studio and when out painting on location. You can use it to match precisely any shade you want to reproduce in your work – the precise green of some leaves, for example, the red of some poppies or the blue of the sea.

The 25 *Winsor & Newton*™ colours chosen for the colour wheels give a comprehensive range of 2400 two-colour mixes. The selected colours have been chosen as the most useful for a wide range of water colour painting. All the colours can be located in the colour charts and matched by mixing only the two colours shown. This innovative method has the great advantage of enabling you to mix the chosen colour with the absolute minimum number of colours, therefore obtaining the cleanest and brightest tints possible. The necessity to add a third or even a fourth colour when attempting to match a colour is avoided. Note that these mixes were made using *Winsor & Newton* colours; colours by other manufacturers will give varying results.

Each pair of colours is shown in five degrees of a mixture and on each colour wheel percentages are marked as a guide to the proportion of each colour that was used to produce the mix. To achieve any colour shown, simply start with one colour at full strength then add the second colour gradually until the desired colour on the wheel is matched.

ABOUT ARTISTS' COLOURS

Winsor & Newton Artists' Water Colours are renowned for the intensity of their finely ground pigments so your mixtures can be diluted to make a very wide range of tints. Even with paints as finely ground as these, some pigment combinations will granulate out when mixed and will not give a perfect flat wash. This affects a few mixtures when heavy pigments separate out before the wash is dry. This property in water colours is highly prized by those painters who desire texture in their washes and many interesting effects can be obtained. To get the strongest granulated washes use rough-textured water colour paper and allow your painting to dry lying flat. Burnt sienna mixed with cobalt blue offers a good example of a granulated effect.

CHOICE OF COLOURS

It may seem surprising that several lovely subtle colours such as terre verte, cerulean, alizarin crimson, rose madder and Potter's pink are not included. This is mainly because their general use is limited and their effect in mixtures is usually weak. By looking at the appropriate colour wheels, you will find very close matches to most of these colours. Experienced painters may find that some of their favourite colours are missing from the charts, but may be surprised by how many of these can be replicated extremely closely by other two-colour combinations.

MIXING COLOUR

When you are mixing colours, start with the lighter colour and gradually add the darker colour to it. In this way, you will avoid mixing too much paint. If you start with too much of the darker or stronger colour, you will need a great deal of the lighter colour to create the tint you are attempting to match. When matching with tube colours, add a little water to the palette first. This will greatly speed up the mixing time and will show the colour you have achieved more clearly.

SUGGESTED PALETTES

It is a good idea for beginners to start with a very restricted palette of six colours and use the charts referring to these six colours to develop their colour skills and discover their preferences. They can then augment their palette as they gain experience. A good minimum palette for a beginner is:

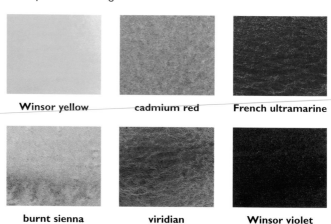

Winsor yellow	cadmium red	French ultramarine
burnt sienna	viridian	Winsor violet

It is interesting to look at the colour palettes of the some of the great painters of the past.

James MacNeill Whistler in his water colours used Prussian blue, raw umber, raw sienna, yellow ochre, vermilion, burnt sienna, Venetian red and black.

Mixing any two of these would give very subdued secondaries. The predominance of the earth colours in this palette demonstrates how he obtained his subtle colour schemes.

Claude Monet, another great colourist, in his atmospheric London paintings said that he used (in oil) only five colours. These were cadmium yellow, vermilion, rose madder deep, cobalt blue and emerald green.

The palette of **William Russell Flint** was cobalt blue, ultramarine, cerulean blue, light red, yellow ochre, Indian yellow, burnt sienna and rose madder. Even this small group would not all have been used in any one picture.

Rowland Hilder had 27 colours in his paintbox but rarely used more than eight in any one painting. Many of his neutral greys were made with lamp black and a touch of burnt sienna or payne's gray and a touch of ultramarine.

Brushes come in many shapes and sizes, but most of those suitable for water colour are made from sable or other animal hair, or synthetics. Hog hair brushes are used mostly by oil painters.

how to use this book

Each double page spread features a named colour from the range below. In practice most artists will use far fewer colours than this. To each base colour are added named colour mixers in different percentage strengths which will help you to achieve the precise shade you want. The colours are organized into colour groups: yellows, reds, purples, blues, greens and neutrals, with mix colours chosen as being of most use to artists in water colour. The hue variations information at the foot of each double-page spread shows you where to look if your mix is not quite what you want.

THE WATER COLOUR PALETTE

Winsor & Newton™ are the most popular water colours manufactured, available in art stores and via the Internet. Colours included in many pre-selected painting boxes are also chosen from this range.

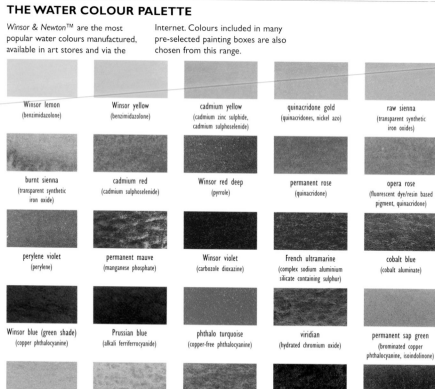

Winsor lemon
(benzimidazolone)

Winsor yellow
(benzimidazolone)

cadmium yellow
(cadmium zinc sulphide,
cadmium sulphoselenide)

quinacridone gold
(quinacridones, nickel azo)

raw sienna
(transparent synthetic
iron oxides)

burnt sienna
(transparent synthetic
iron oxide)

cadmium red
(cadmium sulphoselenide)

Winsor red deep
(pyrrole)

permanent rose
(quinacridone)

opera rose
(fluorescent dye/resin based
pigment, quinacridone)

perylene violet
(perylene)

permanent mauve
(manganese phosphate)

Winsor violet
(carbozole dioxazine)

French ultramarine
(complex sodium aluminium
silicate containing sulphur)

cobalt blue
(cobalt aluminate)

Winsor blue (green shade)
(copper phthalocyanine)

Prussian blue
(alkali ferriferrocyanine)

phthalo turquoise
(copper-free phthalocyanine)

viridian
(hydrated chromium oxide)

permanent sap green
(brominated copper
phthalocyanine, isoindolinone)

olive green
(synthetic iron oxide, chlorinated
copper phthalocyanine)

raw umber
(natural iron oxide)

burnt umber
(natural and
synthetic iron oxides)

sepia
(carbon black,
synthetic iron oxide)

Payne's gray
(copper phthalocyanine, carbon
black, quinacridone)

Use the at-a-glance percentage mixes to see what will result from a mix of two colours in a range of five different percentage strengths. The colour at the centre of the "wheel" is 100 per cent of the colour named on the spread; the ends of the "spokes" are 100 per cent strength mixer colour.

section colour each colour section is organized around a primary or secondary colour, or a neutral.

percentage mix the percentages of each colour are indicated, from full strength main shade at the centre to full-strength second colour at the edge.

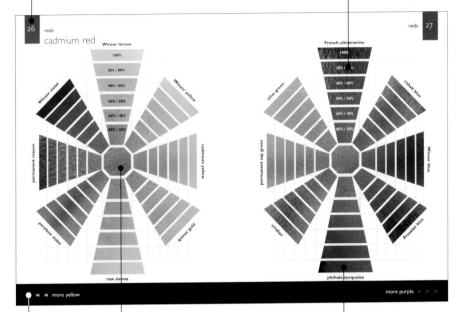

hue variations if your mix is not right, going back in the selector will give mixes containing more of a different primary.

base colour one of the 25 colours shown opposite appears on every spread, with mixes of percentages of further colours.

mix colour full-strength swatches of the mixer colour appear at the ends of the spokes of the colour wheel.

papers and brushes

Storing your brushes
upright resting on the
handle will keep the
bristles in good
condition. If treated
well brushes will last
for many years.

Water colour painting requires very little equipment: pan or tube paints, sable or synthetic brushes, good paper and clean water. In water colour, fine pigments produce clear bright washes which can be modified by the slightest amount of other colours. This gives the medium great subtlety and flexibility but if the water in your jar is tinted then all your colours are being mixed with that tint, however pale it is. It may not be particularly noticeable to you but it is happening. The ideal solution is to use two large clear jars so that you can see how much the water is coloured and use one to wash your brushes and the other to add water to your colours. In practice, most artists use only one jar, particularly when painting outdoors and change the water frequently.

To ensure the greatest colour accuracy, all the colour patches in this book were mixed with clean boiled water and a brush washed under the tap when each patch was finished, until the water ran clear.

WATER COLOUR PAPERS

The paper you choose will have a great influence on the way your paints work and it is advisable to try a selection before investing in large pads of one type of paper. The surface preferred by many artists is a good-quality rough (or "Not") water colour paper but much fine work has been done on papers and boards which were not originally intended as a painting surface. Tinted papers can also be used and on these the contrast between colours will be weaker as every transparent wash will show some of the paper's own colour through it. J.M.W. Turner used many types of paper including writing papers, and had slate-grey paper bound into sketchbooks for his Venice

studies. To counter the darkness of the paper, he added white to his lighter tones. This is now standard practice with artists working on tinted papers. Most of the papers in his sketchbooks have quite smooth surfaces.

BRUSHES

The range of brushes now available is enormous. Pure sable brushes are the highest quality, but expensive; combinations of synthetics and sable, such as *Winsor & Newton* Sceptre Gold™ II, and the synthetic Galeria™ range offer superior quality at an affordable price. A good starting set of brushes for most needs includes: pointed sable brushes up to size 14 for tight control and accuracy; a couple of riggers for drawing long continuous lines (these can be synthetic or sable); broad flat synthetic wash brushes, ½in, 1in, 2in; and a mop brush of squirrel hair for wetting the paper and brushing in large areas.

Try out lots of different paper textures to find out which best suits your style of work. Paint patches of different colours on different surfaces to see how they react.

the
colour mixes

The following pages feature 25 main colours from the *Winsor & Newton*™ Artists' Water Colour range, the most popular range with amateur and professional artists. The mixes provide excellent evidence of how few colours a painter actually needs to produce bright, vibrant colours in water colour. Use these mixes as guides to help you to achieve the exact shade you want, whatever your subject.

Winsor lemon

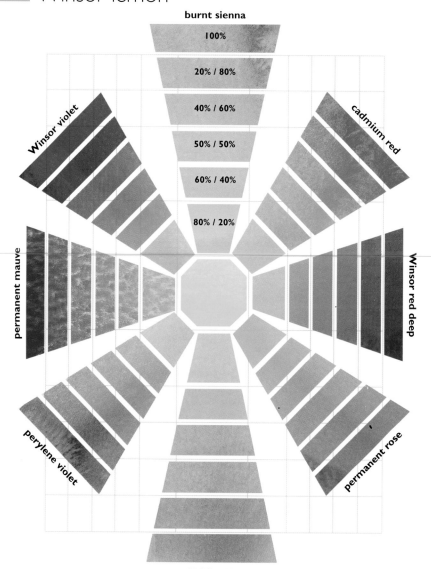

burnt sienna

100%

20% / 80%

40% / 60%

50% / 50%

60% / 40%

80% / 20%

Winsor violet

cadmium red

permanent mauve

Winsor red deep

perylene violet

permanent rose

opera rose

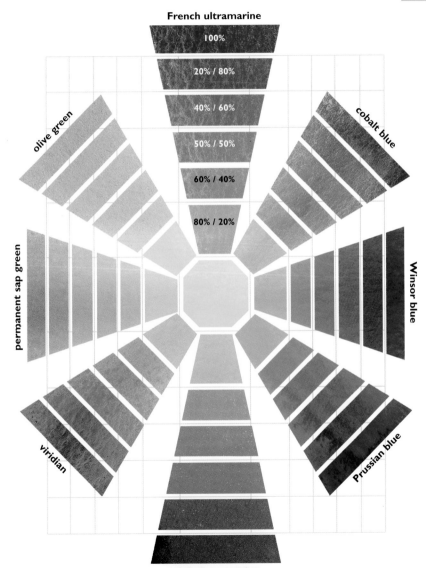

French ultramarine

100%

20% / 80%

40% / 60%

50% / 50%

60% / 40%

80% / 20%

olive green

cobalt blue

permanent sap green

Winsor blue

viridian

Prussian blue

phthalo turquoise

Winsor yellow

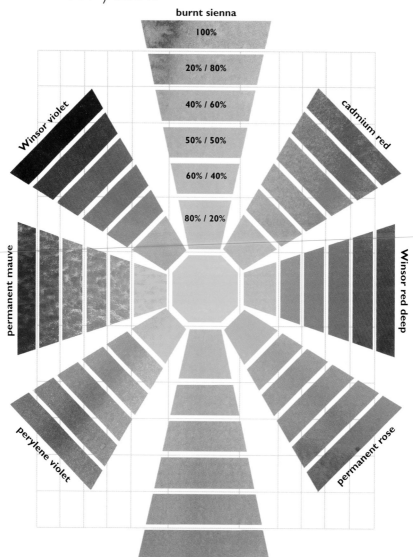

burnt sienna

100%

20% / 80%

40% / 60%

50% / 50%

60% / 40%

80% / 20%

Winsor violet

cadmium red

permanent mauve

Winsor red deep

perylene violet

permanent rose

opera rose

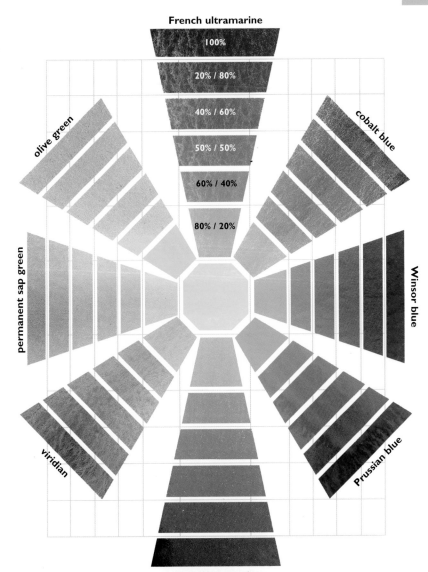

French ultramarine

100%

20% / 80%

40% / 60%

50% / 50%

60% / 40%

80% / 20%

olive green

cobalt blue

permanent sap green

Winsor blue

viridian

Prussian blue

phthalo turquoise

cadmium yellow

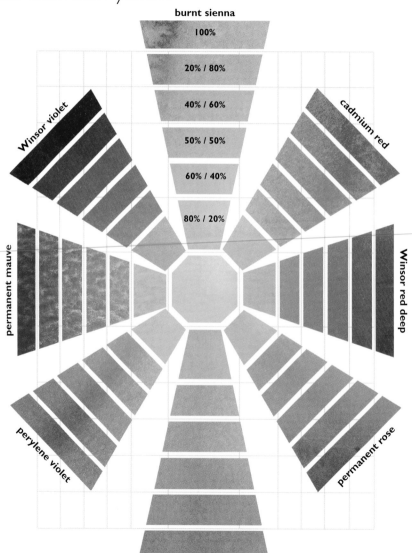

burnt sienna

100%

20% / 80%

40% / 60%

50% / 50%

60% / 40%

80% / 20%

Winsor violet

cadmium red

permanent mauve

Winsor red deep

perylene violet

permanent rose

opera rose

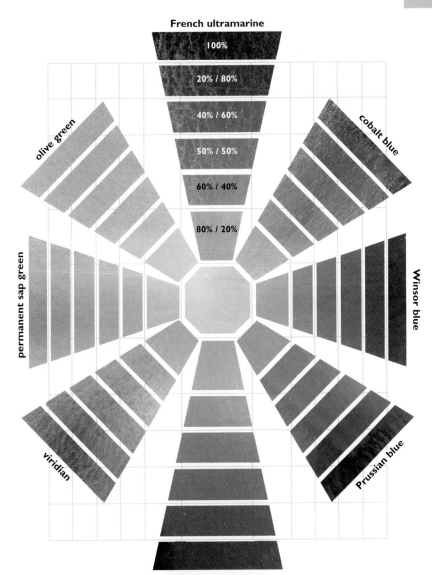

French ultramarine

100%

20% / 80%

40% / 60%

50% / 50%

60% / 40%

80% / 20%

olive green

cobalt blue

permanent sap green

Winsor blue

viridian

Prussian blue

phthalo turquoise

yellows
quinacridone gold

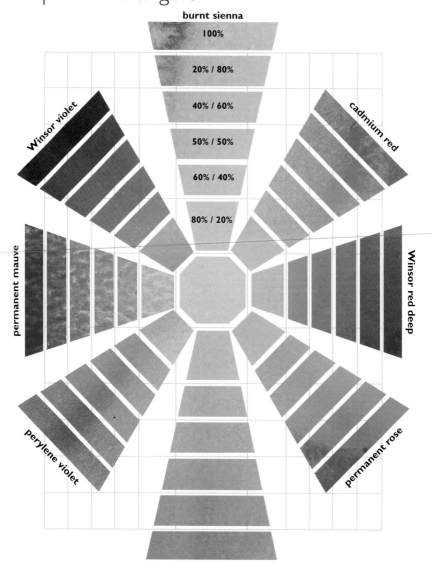

burnt sienna

100%

20% / 80%

40% / 60%

50% / 50%

60% / 40%

80% / 20%

Winsor violet

cadmium red

permanent mauve

Winsor red deep

perylene violet

permanent rose

opera rose

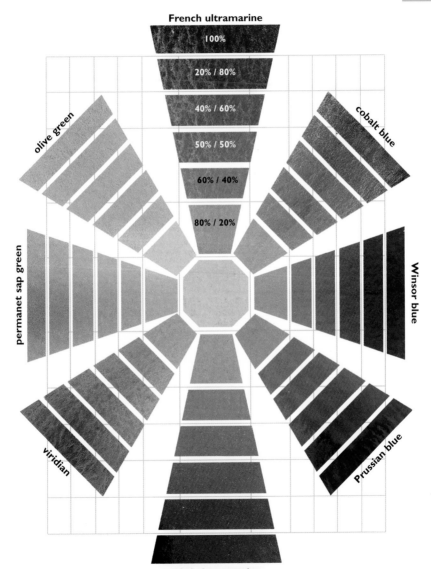

French ultramarine

100%

20% / 80%

40% / 60%

50% / 50%

60% / 40%

80% / 20%

olive green

cobalt blue

permanet sap green

Winsor blue

viridian

Prussian blue

phthalo turquoise

raw sienna

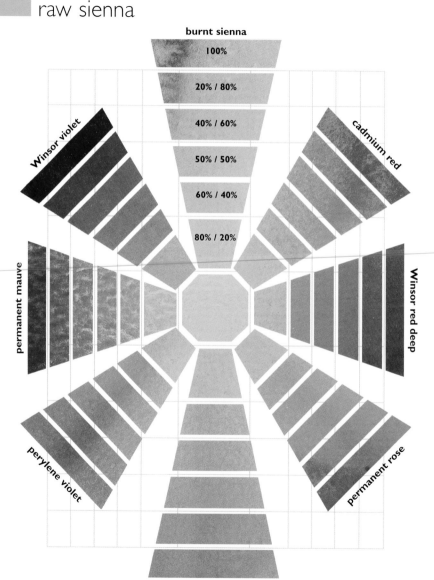

burnt sienna

100%

20% / 80%

40% / 60%

50% / 50%

60% / 40%

80% / 20%

Winsor violet

cadmium red

permanent mauve

Winsor red deep

perylene violet

permanent rose

opera rose

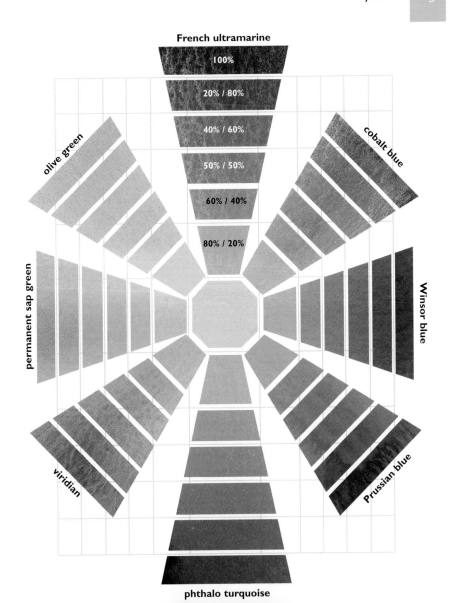

French ultramarine

100%

20% / 80%

40% / 60%

50% / 50%

60% / 40%

80% / 20%

olive green

cobalt blue

permanent sap green

Winsor blue

viridian

Prussian blue

phthalo turquoise

burnt sienna

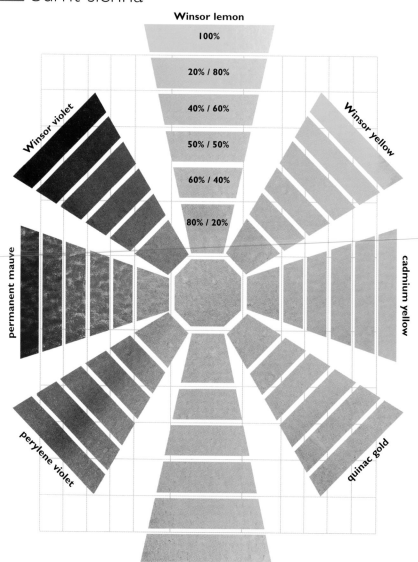

Winsor lemon

100%

20% / 80%

40% / 60%

50% / 50%

60% / 40%

80% / 20%

Winsor violet

Winsor yellow

permanent mauve

cadmium yellow

perylene violet

quinac gold

raw sienna

French ultramarine

100%

20% / 80%

40% / 60%

50% / 50%

60% / 40%

80% / 20%

olive green

cobalt blue

permanent sap green

Winsor blue

viridian

Prussian blue

phthalo turquoise

cadmium red

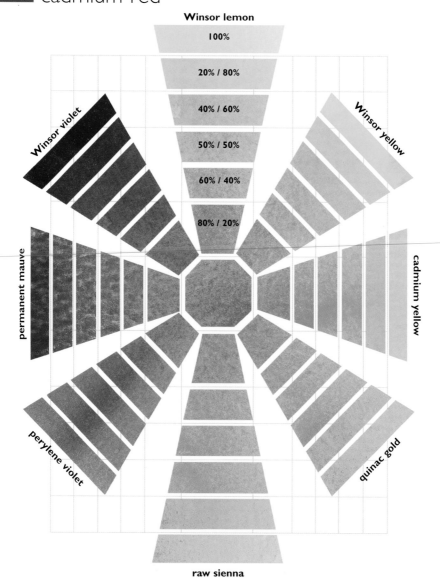

Winsor lemon

100%

20% / 80%

40% / 60%

50% / 50%

60% / 40%

80% / 20%

Winsor violet

Winsor yellow

permanent mauve

cadmium yellow

perylene violet

quinac gold

raw sienna

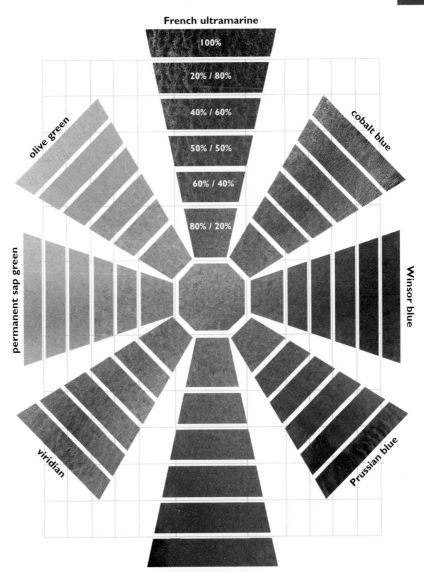

French ultramarine

100%

20% / 80%

40% / 60%

50% / 50%

60% / 40%

80% / 20%

olive green

cobalt blue

permanent sap green

Winsor blue

viridian

Prussian blue

phthalo turquoise

Winsor red deep

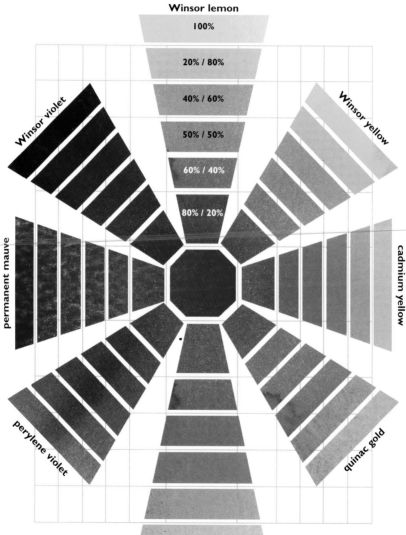

Winsor lemon

100%

20% / 80%

40% / 60%

50% / 50%

60% / 40%

80% / 20%

Winsor violet

Winsor yellow

permanent mauve

cadmium yellow

perylene violet

quinac gold

raw sienna

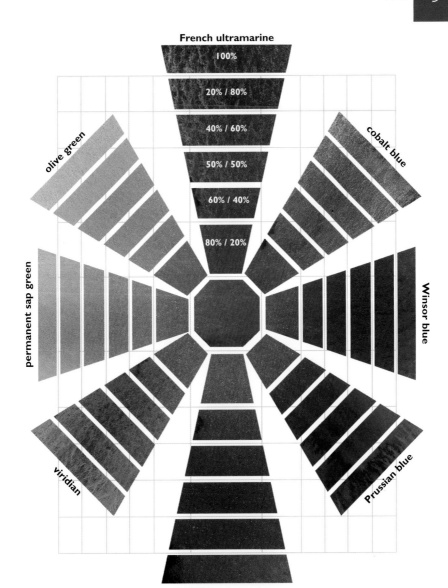

French ultramarine

100%

20% / 80%

40% / 60%

50% / 50%

60% / 40%

80% / 20%

olive green

cobalt blue

permanent sap green

Winsor blue

viridian

Prussian blue

phthalo turquoise

permanent rose

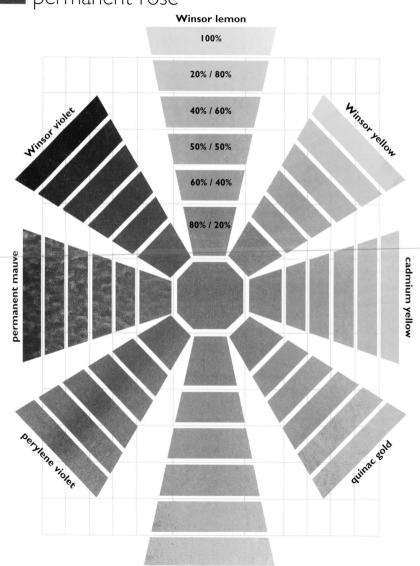

Winsor lemon

100%

20% / 80%

40% / 60%

50% / 50%

60% / 40%

80% / 20%

Winsor violet

Winsor yellow

permanent mauve

cadmium yellow

perylene violet

quinac gold

raw sienna

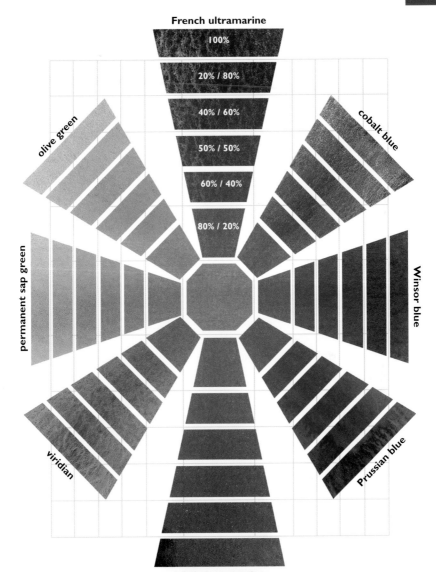

French ultramarine

100%

20% / 80%

40% / 60%

50% / 50%

60% / 40%

80% / 20%

olive green

cobalt blue

permanent sap green

Winsor blue

viridian

Prussian blue

phthalo turquoise

opera rose

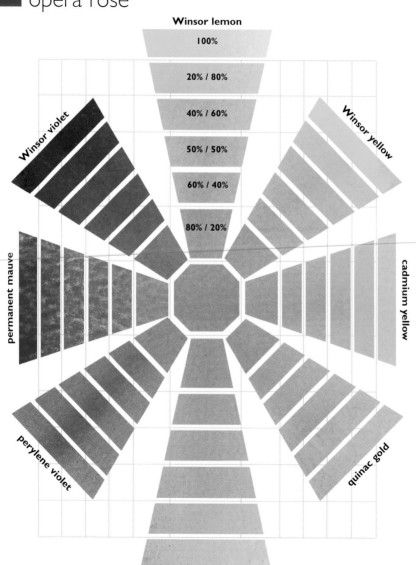

Winsor lemon

100%

20% / 80%

40% / 60%

50% / 50%

60% / 40%

80% / 20%

Winsor violet

Winsor yellow

permanent mauve

cadmium yellow

perylene violet

quinac gold

raw sienna

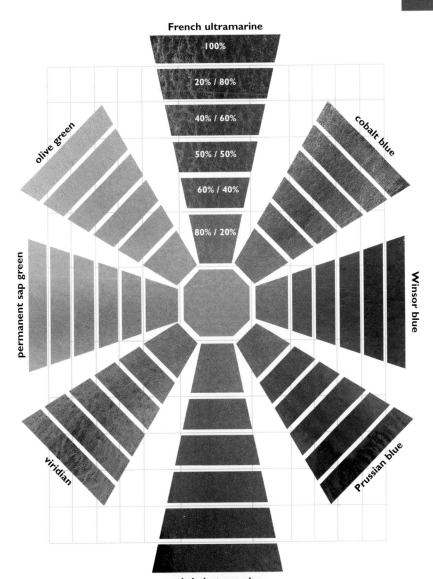

French ultramarine

100%

20% / 80%

40% / 60%

50% / 50%

60% / 40%

80% / 20%

olive green

cobalt blue

permanent sap green

Winsor blue

viridian

Prussian blue

phthalo turquoise

perylene violet

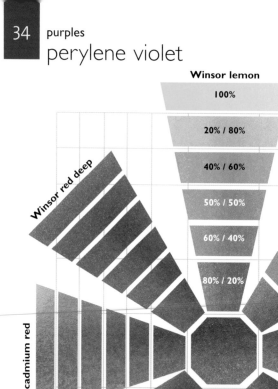
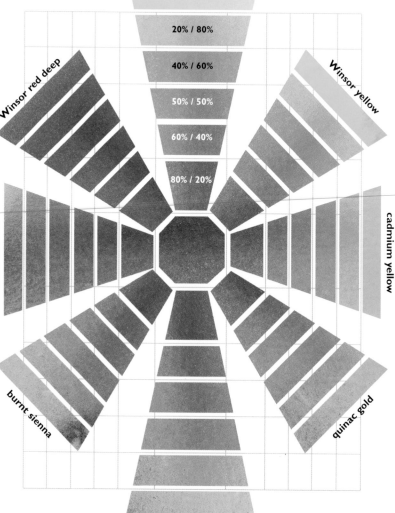

Winsor lemon

100%

20% / 80%

40% / 60%

50% / 50%

60% / 40%

80% / 20%

Winsor red deep

Winsor yellow

cadmium red

cadmium yellow

burnt sienna

quinac gold

raw sienna

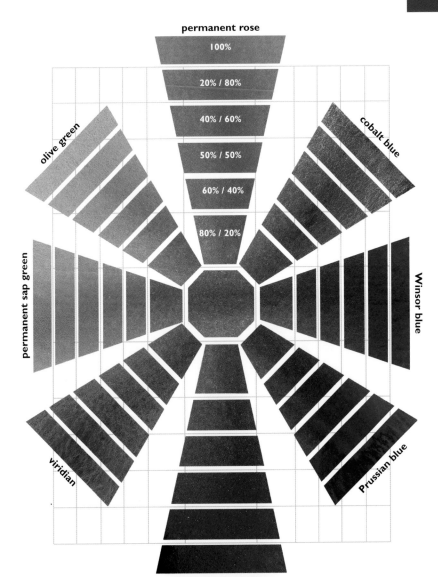

permanent rose

100%

20% / 80%

40% / 60%

50% / 50%

60% / 40%

80% / 20%

olive green

cobalt blue

permanent sap green

Winsor blue

viridian

Prussian blue

phthalo turquoise

permanent mauve

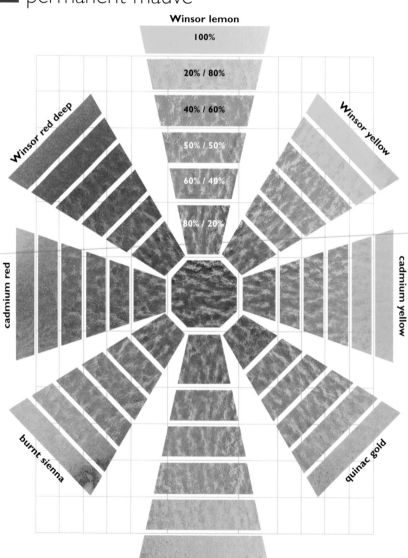

Winsor lemon
100%
20% / 80%
40% / 60%
50% / 50%
60% / 40%
80% / 20%

Winsor red deep

Winsor yellow

cadmium red

cadmium yellow

burnt sienna

quinac gold

raw sienna

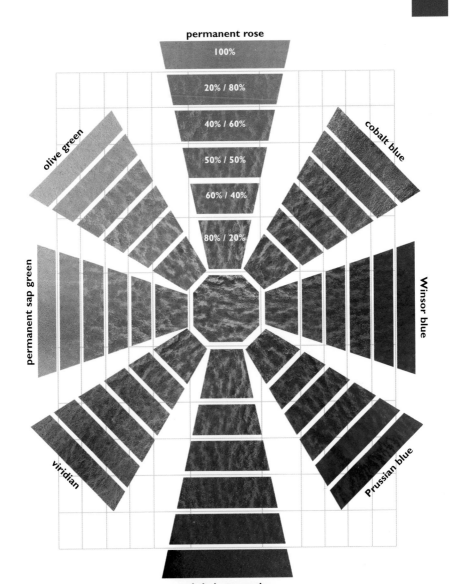

permanent rose

100%

20% / 80%

40% / 60%

50% / 50%

60% / 40%

80% / 20%

olive green

cobalt blue

permanent sap green

Winsor blue

viridian

Prussian blue

phthalo turquoise

Winsor violet

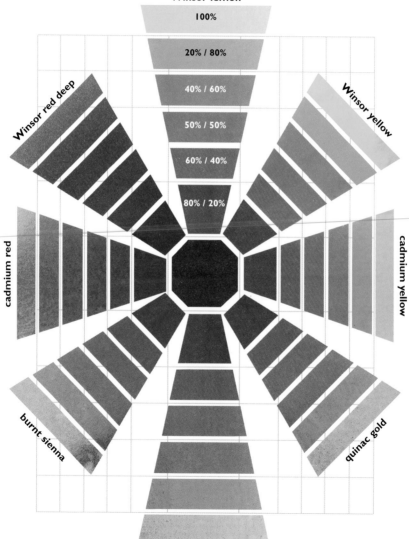

Winsor lemon

100%

20% / 80%

40% / 60%

50% / 50%

60% / 40%

80% / 20%

Winsor red deep

Winsor yellow

cadmium red

cadmium yellow

burnt sienna

quinac gold

raw sienna

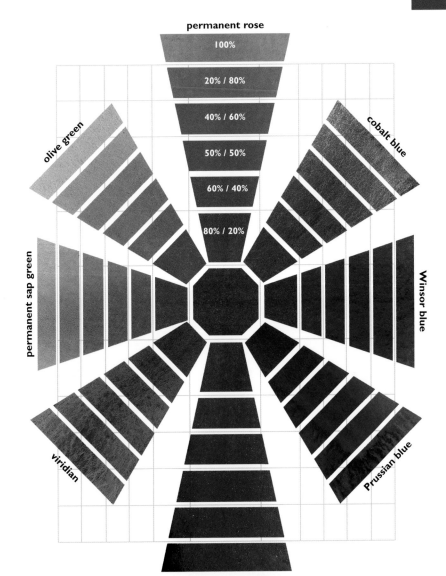

permanent rose

100%

20% / 80%

40% / 60%

50% / 50%

60% / 40%

80% / 20%

olive green

cobalt blue

permanent sap green

Winsor blue

viridian

Prussian blue

phthalo turquoise

French ultramarine

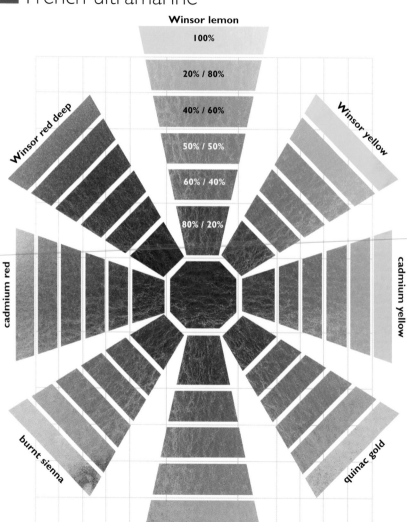

Winsor lemon

100%

20% / 80%

40% / 60%

50% / 50%

60% / 40%

80% / 20%

Winsor red deep

Winsor yellow

cadmium red

cadmium yellow

burnt sienna

quinac gold

raw sienna

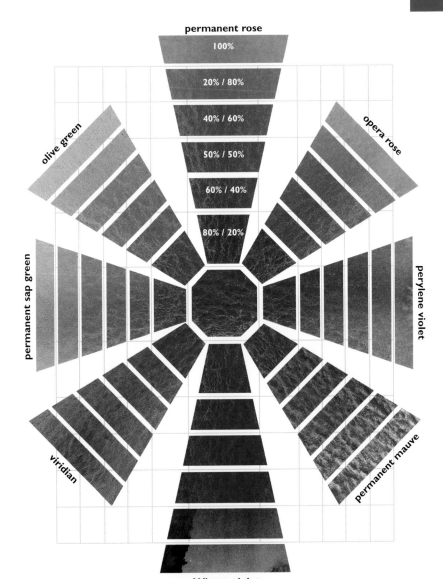

permanent rose

100%

20% / 80%

40% / 60%

50% / 50%

60% / 40%

80% / 20%

olive green

opera rose

permanent sap green

perylene violet

viridian

permanent mauve

Winsor violet

cobalt blue

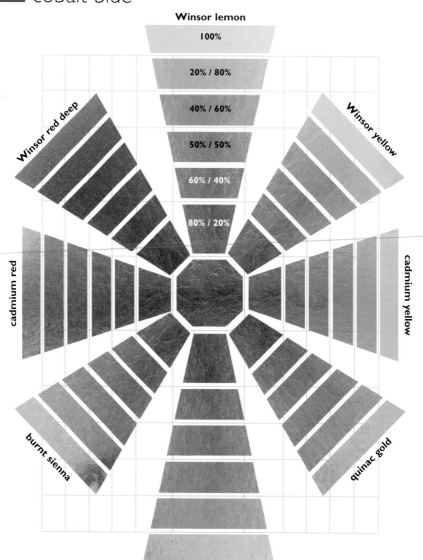

Winsor lemon

100%

20% / 80%

40% / 60%

50% / 50%

60% / 40%

80% / 20%

Winsor red deep

Winsor yellow

cadmium red

cadmium yellow

burnt sienna

quinac gold

raw sienna

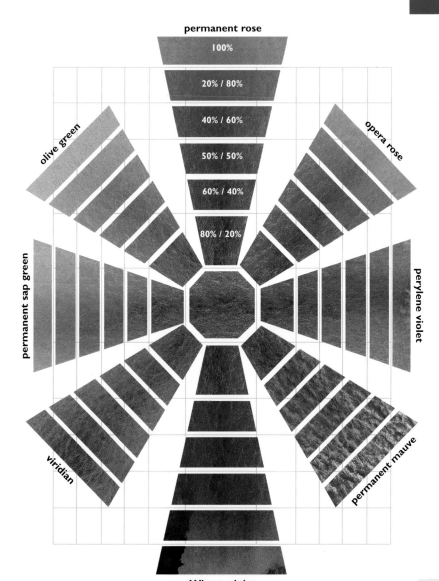

permanent rose

100%

20% / 80%

40% / 60%

50% / 50%

60% / 40%

80% / 20%

olive green

opera rose

permanent sap green

perylene violet

viridian

permanent mauve

Winsor violet

Winsor blue (green shade)

Winsor lemon

100%

20% / 80%

40% / 60%

50% / 50%

60% / 40%

80% / 20%

Winsor red deep

Winsor yellow

cadmium red

cadmium yellow

burnt sienna

quinac gold

raw sienna

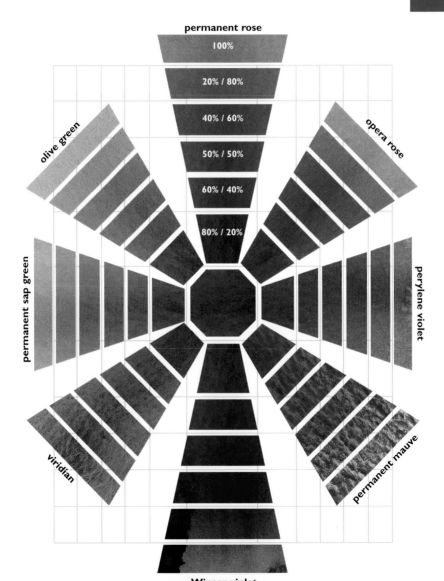

permanent rose

100%

20% / 80%

40% / 60%

50% / 50%

60% / 40%

80% / 20%

olive green

opera rose

permanent sap green

perylene violet

viridian

permanent mauve

Winsor violet

Prussian blue

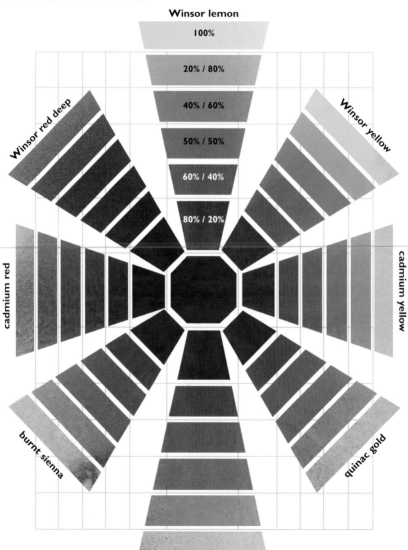

Winsor lemon

100%

20% / 80%

40% / 60%

50% / 50%

60% / 40%

80% / 20%

Winsor red deep

Winsor yellow

cadmium red

cadmium yellow

burnt sienna

quinac gold

raw sienna

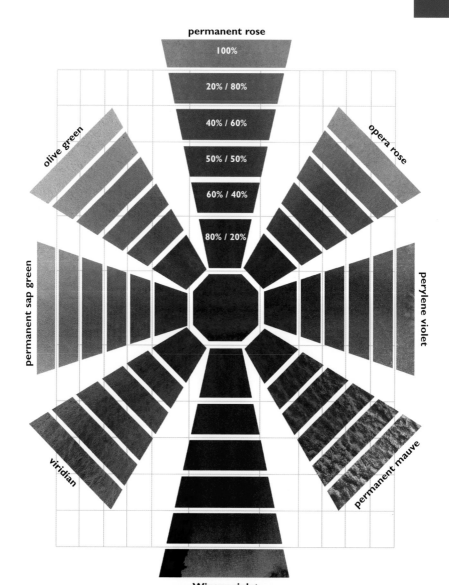

permanent rose

100%

20% / 80%

40% / 60%

50% / 50%

60% / 40%

80% / 20%

olive green

opera rose

permanent sap green

perylene violet

viridian

permanent mauve

Winsor violet

phthalo turquoise

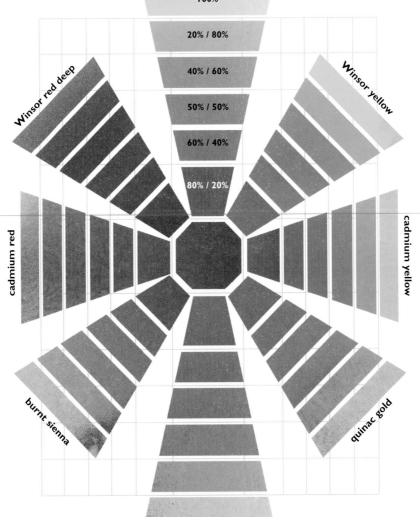

Winsor lemon

100%

20% / 80%

40% / 60%

50% / 50%

60% / 40%

80% / 20%

Winsor red deep

Winsor yellow

cadmium red

cadmium yellow

burnt sienna

quinac gold

raw sienna

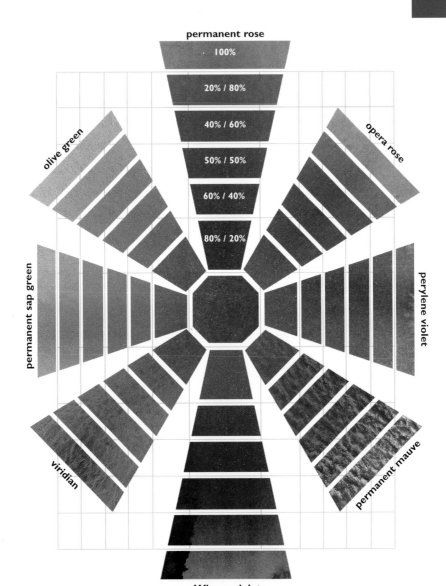

permanent rose

100%

20% / 80%

40% / 60%

50% / 50%

60% / 40%

80% / 20%

olive green

opera rose

permanent sap green

perylene violet

viridian

permanent mauve

Winsor violet

viridian

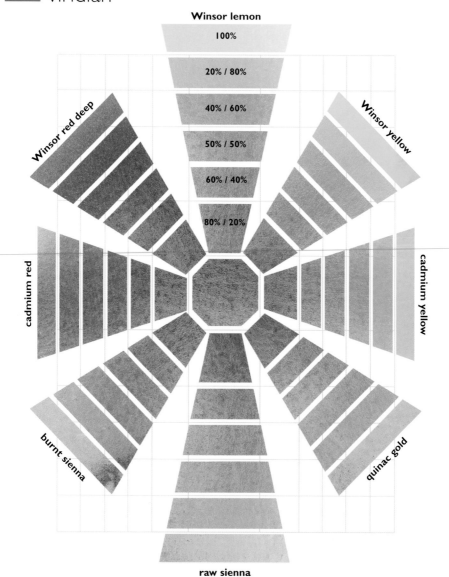

Winsor lemon

100%

20% / 80%

40% / 60%

50% / 50%

60% / 40%

80% / 20%

Winsor red deep

Winsor yellow

cadmium red

cadmium yellow

burnt sienna

quinac gold

raw sienna

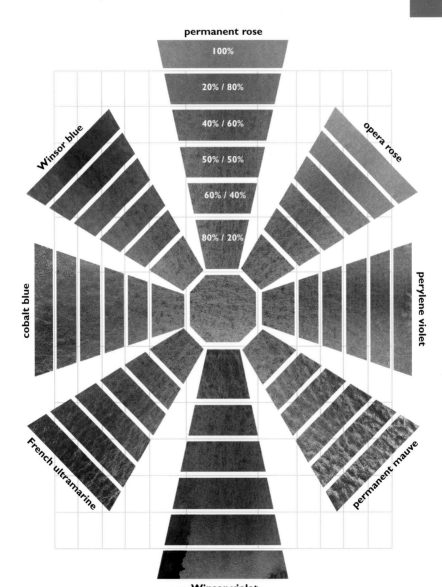

permanent rose

100%

20% / 80%

40% / 60%

50% / 50%

60% / 40%

80% / 20%

Winsor blue

opera rose

cobalt blue

perylene violet

French ultramarine

permanent mauve

Winsor violet

permanent sap green

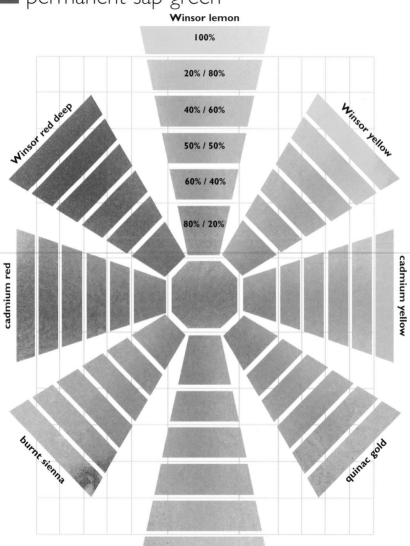

Winsor lemon

100%

20% / 80%

40% / 60%

50% / 50%

60% / 40%

80% / 20%

Winsor red deep

Winsor yellow

cadmium red

cadmium yellow

burnt sienna

quinac gold

raw sienna

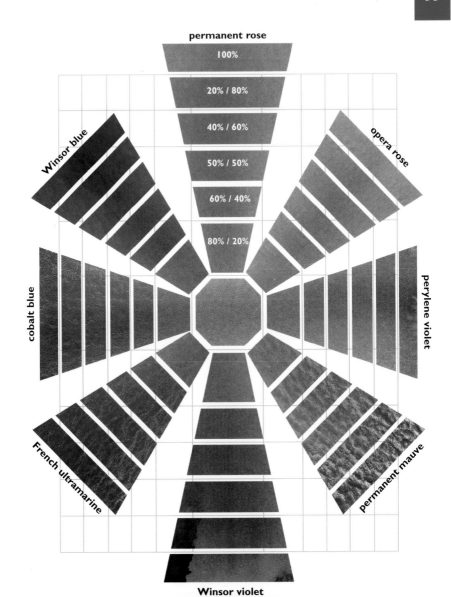

permanent rose

100%

20% / 80%

40% / 60%

50% / 50%

60% / 40%

80% / 20%

Winsor blue

opera rose

cobalt blue

perylene violet

French ultramarine

permanent mauve

Winsor violet

olive green

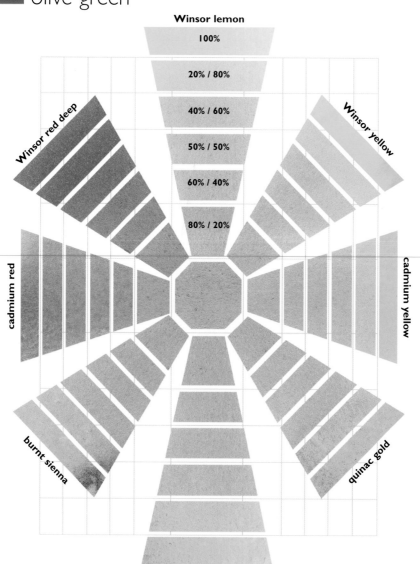

Winsor lemon

100%

20% / 80%

40% / 60%

50% / 50%

60% / 40%

80% / 20%

Winsor red deep

Winsor yellow

cadmium red

cadmium yellow

burnt sienna

quinac gold

raw sienna

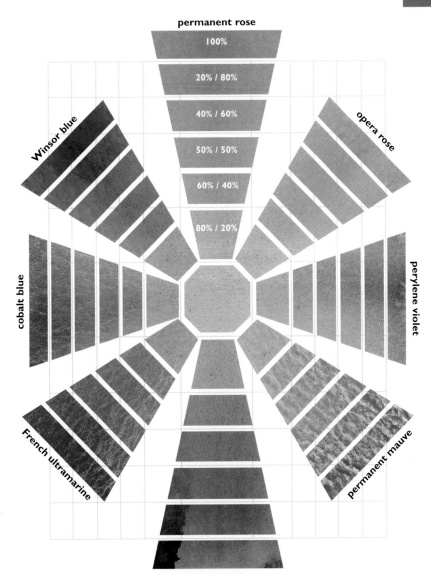

permanent rose

100%

20% / 80%

40% / 60%

50% / 50%

60% / 40%

80% / 20%

Winsor blue

opera rose

cobalt blue

perylene violet

French ultramarine

permanent mauve

Winsor violet

raw umber

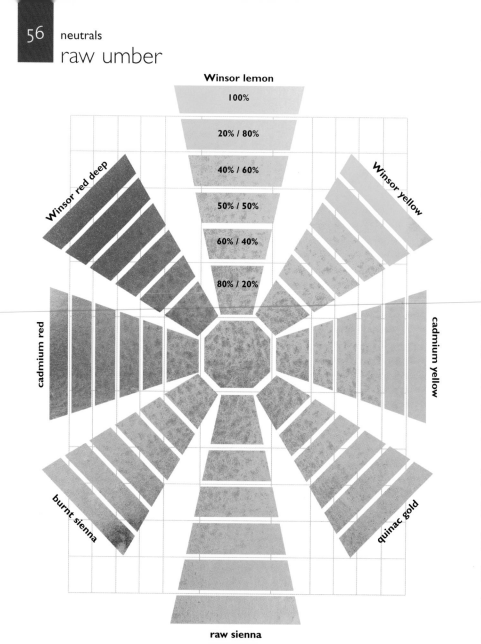

Winsor lemon

100%

20% / 80%

40% / 60%

50% / 50%

60% / 40%

80% / 20%

Winsor red deep

Winsor yellow

cadmium red

cadmium yellow

burnt sienna

quinac gold

raw sienna

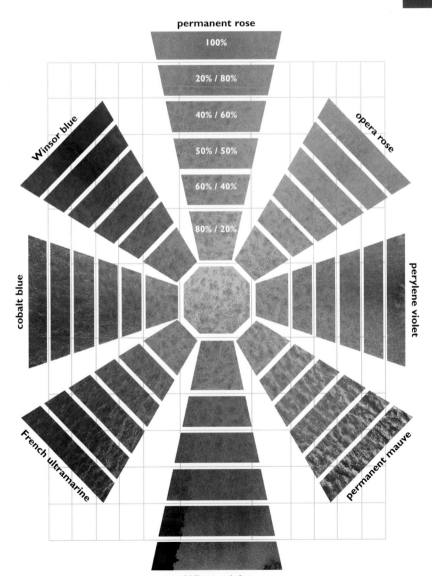

permanent rose

100%

20% / 80%

40% / 60%

50% / 50%

60% / 40%

80% / 20%

Winsor blue

opera rose

cobalt blue

perylene violet

French ultramarine

permanent mauve

Winsor violet

burnt umber

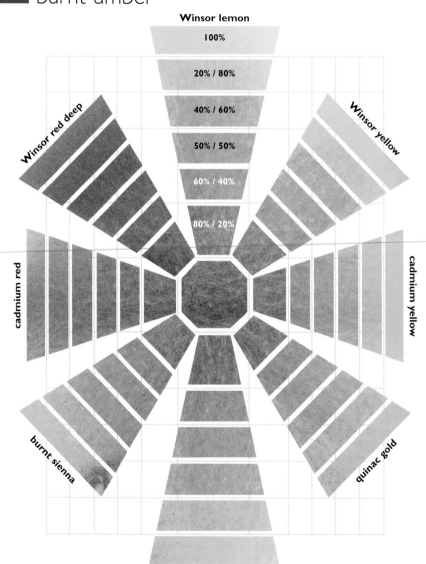

Winsor lemon

100%

20% / 80%

40% / 60%

50% / 50%

60% / 40%

80% / 20%

Winsor red deep

Winsor yellow

cadmium red

cadmium yellow

burnt sienna

quinac gold

raw sienna

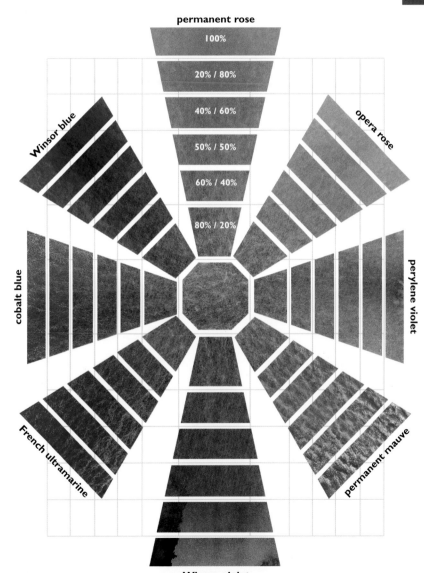

permanent rose

100%

20% / 80%

40% / 60%

50% / 50%

60% / 40%

80% / 20%

Winsor blue

opera rose

cobalt blue

perylene violet

French ultramarine

permanent mauve

Winsor violet

sepia

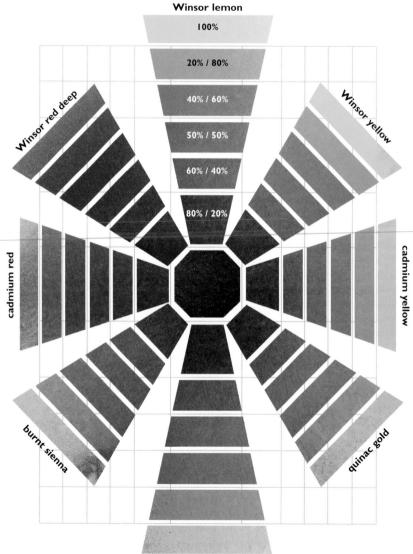

Winsor lemon

100%

20% / 80%

40% / 60%

50% / 50%

60% / 40%

80% / 20%

Winsor red deep

Winsor yellow

cadmium red

cadmium yellow

burnt sienna

quinac gold

raw sienna

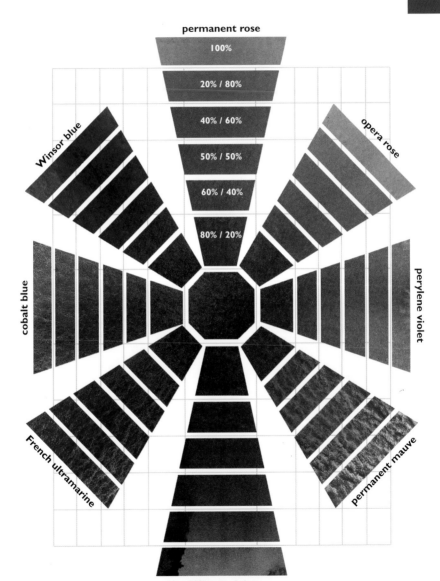

permanent rose

100%

20% / 80%

40% / 60%

50% / 50%

60% / 40%

80% / 20%

Winsor blue

opera rose

cobalt blue

perylene violet

French ultramarine

permanent mauve

Winsor violet

Payne's gray

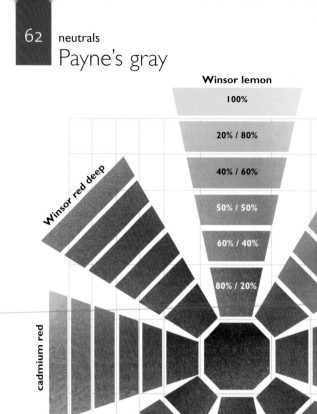

Winsor lemon

100%

20% / 80%

40% / 60%

50% / 50%

60% / 40%

80% / 20%

Winsor red deep

Winsor yellow

cadmium red

cadmium yellow

burnt sienna

quinac gold

raw sienna

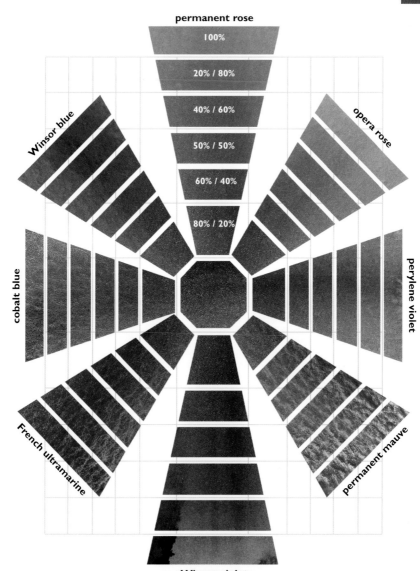

permanent rose

100%

20% / 80%

40% / 60%

50% / 50%

60% / 40%

80% / 20%

Winsor blue

opera rose

cobalt blue

perylene violet

French ultramarine

permanent mauve

Winsor violet

index

brushes 6–7, 10, 11
burnt sienna 6, 14, 16, 18, 20, 22, 24–25, 34, 36, 38, 40, 42, 44, 46, 48, 50, 52, 54, 56, 58, 60, 62
burnt umber 58–59

cadmium red 6, 14, 16, 18, 20, 22, 26–27, 34, 36, 38, 40, 42, 44, 46, 48, 50, 52, 54, 56, 58, 60, 62
cadmium yellow 18–19, 24, 26, 28, 30, 32, 34, 36, 38, 40, 42, 44, 46, 48, 50, 52, 54, 56, 58, 60, 62
cobalt blue 15, 17, 19, 21, 23, 25, 27, 29, 31, 33, 35, 37, 39, 42–43, 51, 53, 55, 57, 59, 61, 63

Flint, William Russell 7
French ultramarine 6, 15, 17, 19, 21, 23, 25, 27, 29, 31, 33, 40–41, 51, 53, 55, 57, 59, 61, 63

granulated washes 5

Hilder, Rowland 7

mixing water colours 4, 5
Monet, Claude 7

olive green 15, 17, 19, 21, 23, 25, 27, 29, 31, 33, 35, 37, 39, 41, 43, 45, 47, 49, 54–55
opera rose 14, 16, 18, 20, 22, 32–33, 41, 43, 45, 47, 49, 51, 53, 55, 57, 59, 61, 63

palettes 6–7
papers for water colour 10–11
Payne's gray 62–63
permanent mauve 14, 16, 18, 20, 22, 24, 26, 28, 30, 32, 36–37, 41, 43, 45, 47, 49, 51, 53, 55, 57, 59, 61, 63
permanent rose 14, 16, 18, 20, 22, 30–31, 35, 37, 39, 41, 43, 45, 47, 49, 51, 53, 55, 57, 59, 61, 63
permanent sap green 15, 17, 19, 21, 23, 25, 27, 29, 31, 33, 35, 37, 39, 41, 43, 45, 47, 49, 52–53
perylene violet 14, 16, 18, 20, 22, 24, 26, 28, 30, 32, 34–35, 41, 43,

45, 47, 49, 51, 53, 55, 57, 59, 61, 63
phthalo turquoise 15, 17, 19, 21, 23, 25, 27, 29, 31, 33, 35, 37, 39, 48–49
Prussian blue 15, 17, 19, 21, 23, 25, 27, 29, 31, 33, 35, 37, 39, 46–47

quinacridone gold 20–21, 24, 26, 28, 30, 32, 34, 36, 38, 40, 42, 44, 46, 48, 50, 52, 54, 56, 58, 60, 62

raw sienna 22–23, 24, 26, 28, 30, 32, 34, 36, 38, 40, 42, 44, 46, 48, 50, 52, 54, 56, 58, 60, 62
raw umber 56–57

sepia 60–61

viridian 6, 15, 17, 19, 21, 23, 25, 27, 29, 31, 33, 35, 37, 39, 41, 43, 45, 47, 49, 50–51

Whistler, James Macneill 7
Winsor blue (green shade) 15, 17, 19, 21,

23, 25, 27, 29, 31, 33, 35, 37, 39, 44–45, 51, 53, 55, 57, 59, 61, 63
Winsor lemon 14–15, 24, 26, 28, 30, 32, 34, 36, 38, 40, 42, 44, 46, 48, 50, 52, 54, 56, 58, 60, 62
Winsor red deep 14, 16, 18, 20, 22, 28–29, 34, 36, 38, 40, 42, 44, 46, 48, 50, 52, 54, 56, 58, 60, 62
Winsor violet 6, 14, 16, 18, 20, 22, 24, 26, 28, 30, 32, 38–39, 41, 43, 45, 47, 49, 51, 53, 55, 57, 59, 61, 63
Winsor yellow 6, 16–17, 24, 26, 28, 30, 32, 34, 36, 38, 40, 42, 44, 46, 48, 50, 52, 54, 56, 58, 60, 62

acknowledgements

Photographs on pp. 6–7, 10, 11© *Winsor & Newton*